Warmth and Wonder for Your Precious Child . . .

We invite you to share the warmth and wonder of Mary Lowe Williams' tender affirmations and Connie Palen's beautiful photographs which illuminate the uniqueness of every child.

This lovely book powerfully, yet gently, affirms that all children are valuable, and deserve love and acceptance.

My Precious Child is a gift of love for children from 4 to 104. It touches the heart and soothes the spirit. Frequently read this book to your child or yourself and honor the preciousness in each of us.

We are delighted to share these inspiring affirmations with you, and hope they bring you many moments of serenity.

Health Communications, Inc.

Audio Tapes Available

Relaxation tapes available using affirmations from *My Precious Child* for children and adults.

Write to: Tapes
Box 1524
Glenwood Springs, CO 81601

Publisher: Health Communications, Inc.
3201 S.W. 15th Street
Deerfield Beach, Florida 33442-8190

My Precious Child
Affirmations For The Child Within

By Mary Lowe Williams
Photos by Connie Palen

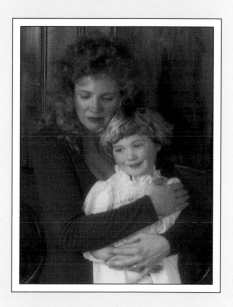

Health Communications, Inc.
Deerfield Beach, Florida

Dedicated to my husband, Leo,
and to my precious children,
Mark and Marla.

You are precious.

I love you.
I *love* you.
I love *you.*

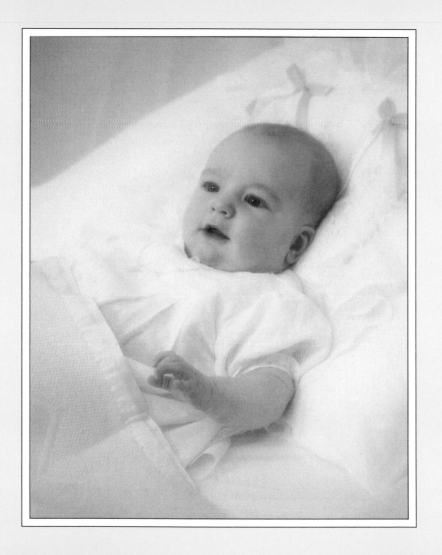

How small and helpless you are.

I will take care of you.
I will teach you to take
care of yourself.

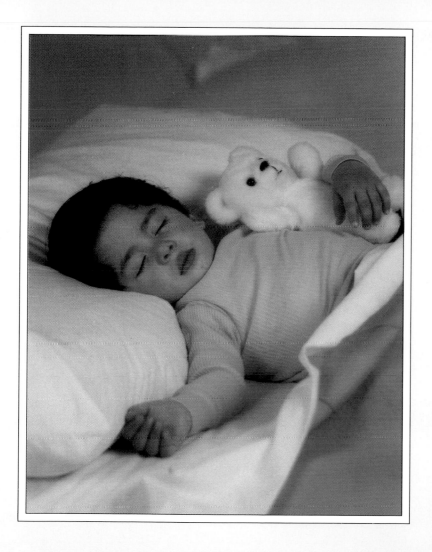

Your feelings are important.

Come to me,
and I will hold
you close.

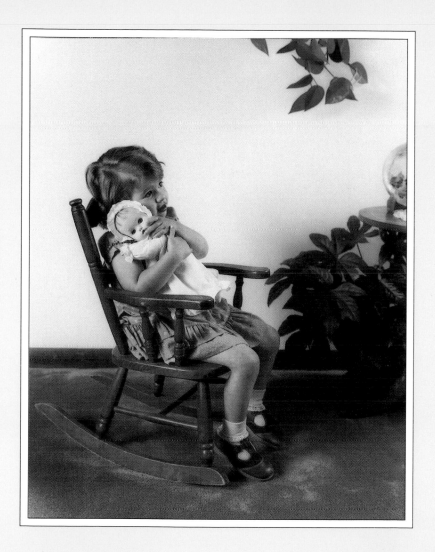

*How quickly you are
growing and changing.*

I love the person
you are becoming.

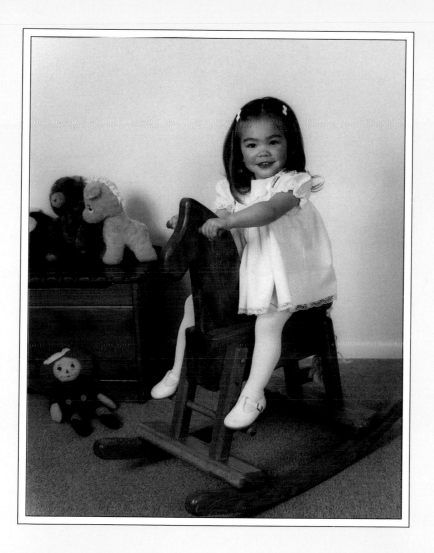

Let's be silly.

We feel happy when we giggle and have fun.

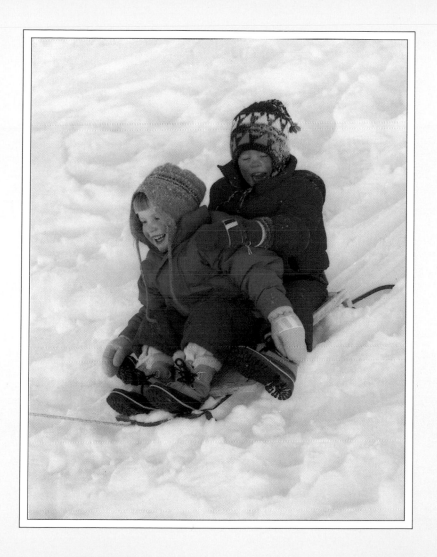

It's okay to feel sad or angry.
It's okay to cry.

I love and
accept you just
the way you are.

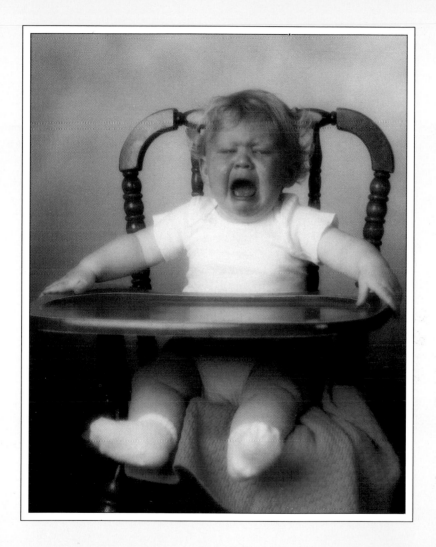

*Take all the time you need
to play and daydream.*

There's no hurry
to grow up.

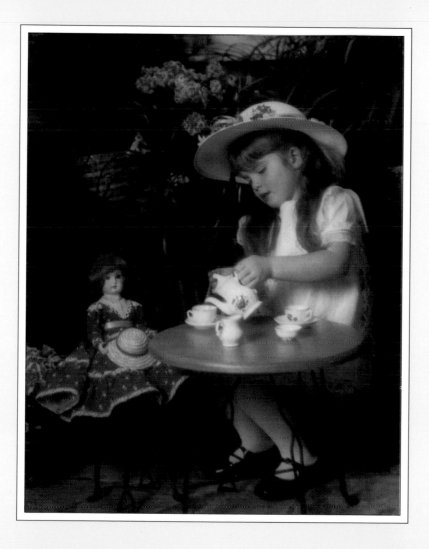

All families have problems.

Our problems are not your fault and you do not need to fix them.

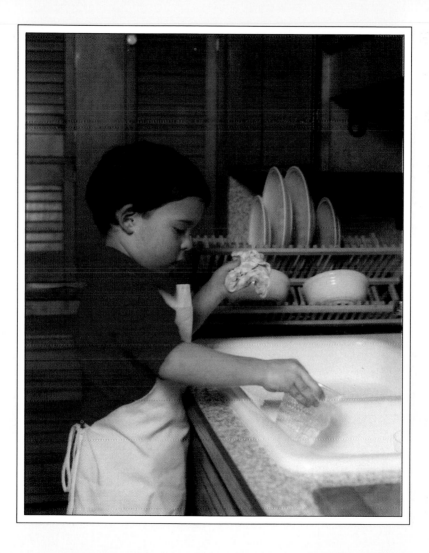

Tell me when you are afraid.

I will listen and be there for you.

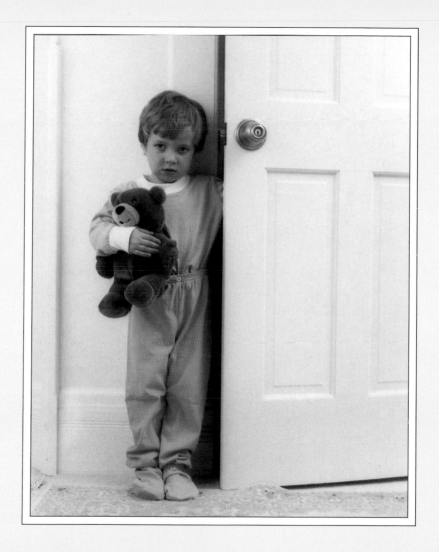

*It's all right to ask
for help.*

Sometimes I
need help, too.

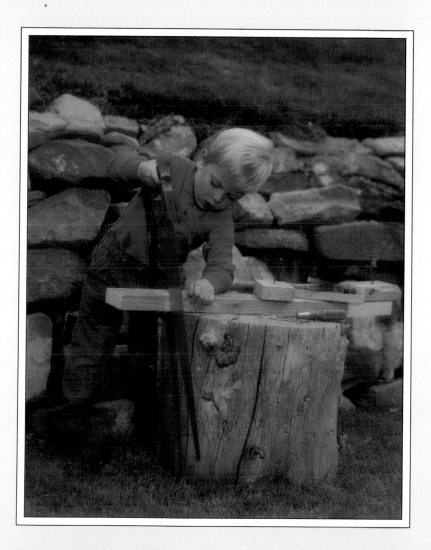

*It's hard to be neat
and tidy.*

Don't worry.
People are more
important than things.

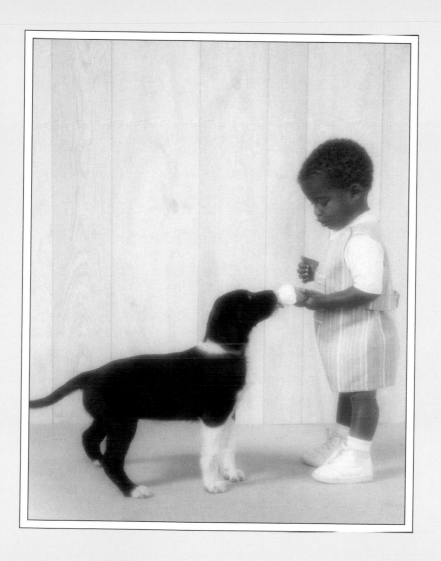

You don't have to be perfect.

I still love you,
even when you make
mistakes.

Sometimes it may seem that everything is more important than you.

I'm sorry if I haven't been there when you needed me.

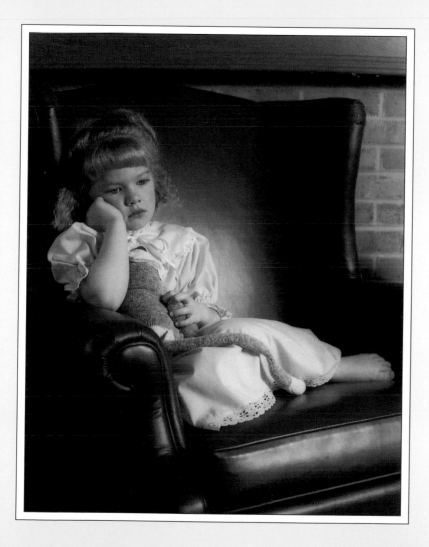

Loneliness hurts.

Sharing a worry can
help it hurt less.

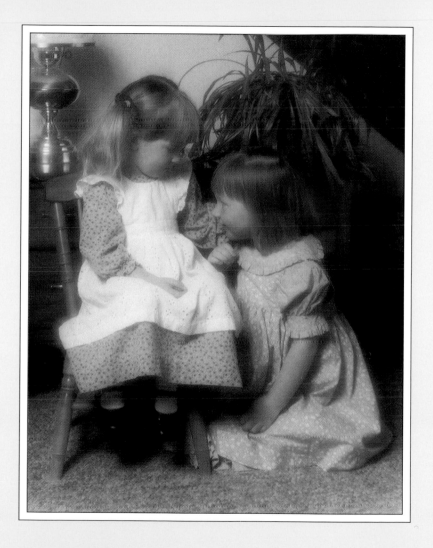

You are beautiful,
inside and out.

I will always
treat you with
love and respect.

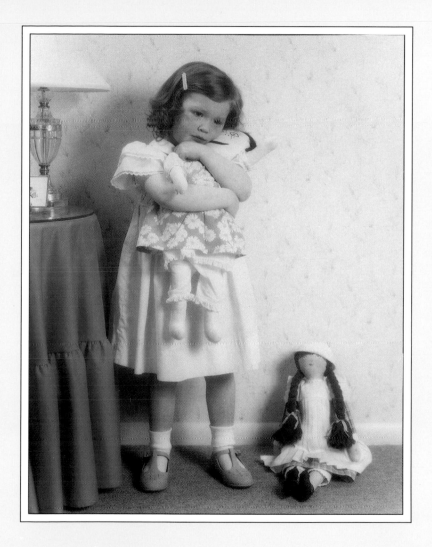

Look what wonderful things
you can learn to do.

I am proud of you.

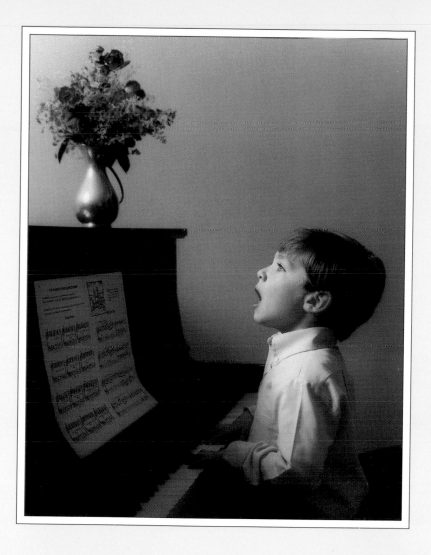

*There is no one
just like you.*

You are
special to me.

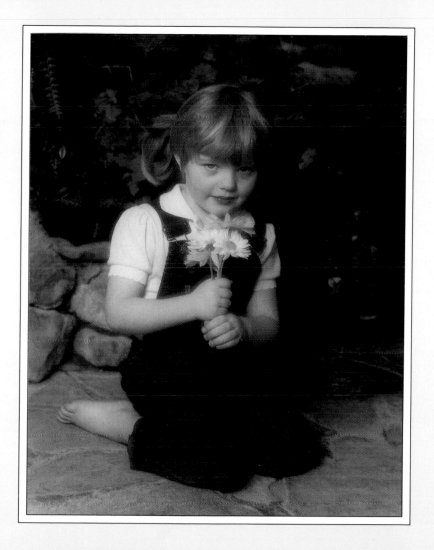

It is wonderful to be a girl.
It is wonderful to be a boy.

I know you can become
anything you want. I will
support and encourage you.

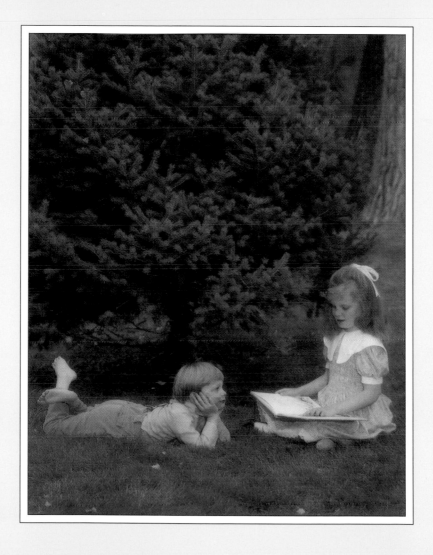

I like being your friend.

I enjoy spending
time with you.

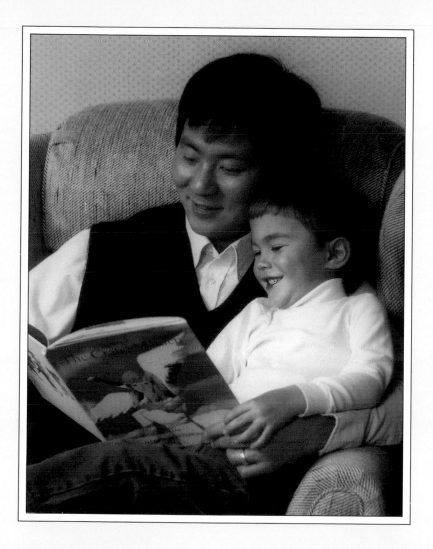

*Your heart is full
of love.*

Thank you for
the happiness you
have given to me.

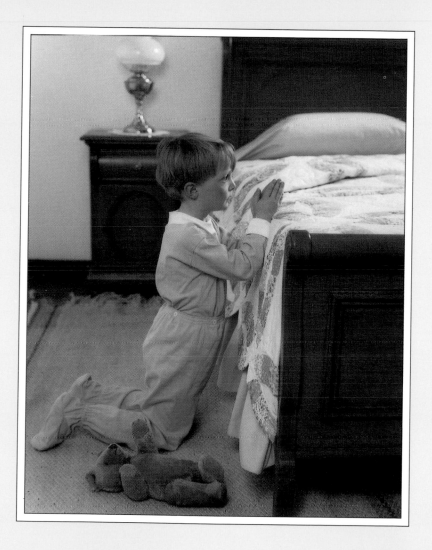

I will always
treasure my
precious child.

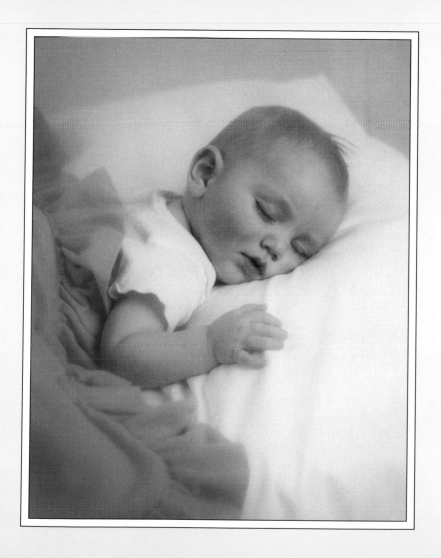